STROUD

HISTORY TOUR

First published 2016

Amberley Publishing
The Hill, Stroud,
Gloucestershire, GL5 4EP
www.amberley-books.com

Copyright © Howard Beard, 2016

The right of Howard Beard to be
identified as the Author of this work
has been asserted in accordance with
the Copyrights, Designs and Patents
Act 1988.

ISBN 978 1 4456 5709 7 (print)
ISBN 978 1 4456 5710 3 (ebook)

British Library Cataloguing in
Publication Data.
A catalogue record for this book is
available from the British Library.

Typesetting by Amberley Publishing.
Printed in Great Britain.

INTRODUCTION

For much of the Middle Ages Stroud was merely a hamlet within the large parish of Bisley. However, by the fourteenth century, it had a church and a nucleus of domestic buildings. By the late 1500s there was also a Friday market. During Elizabethan days expansion took place, which included the construction of a Market House. In the first part of the nineteenth century, after the opening of the Stroudwater Canal, the creation of an efficient toll road system and, especially, the arrival of the Great Western Railway in 1845, the development of Stroud took off, with its centre moving down the hillside to an area around the Subscription Rooms.

The Victorian period was one of great prosperity for Stroud. Many tradesmen, including two of the author's great-grandfathers, moved in to establish businesses in the town as its population increased. Since the Second World War Stroud has acquired a new, distinctive persona, largely based on environmental concerns and the existence of a thriving local artistic community.

The buildings and layout of Stroud reflect its history. It is not picturesque in the sense that many Cotswold towns are, but it is a place full of interest, as this guide proposes to show. The few remaining early properties have Victorian and modern neighbours, making a tour of the town a fascinating architectural experience. In addition, stories relating to its buildings, together with personal anecdotes, help to bring it alive.

Hopefully, both newcomers and local people alike will enjoy using this little book to enrich their knowledge and appreciation of Stroud.

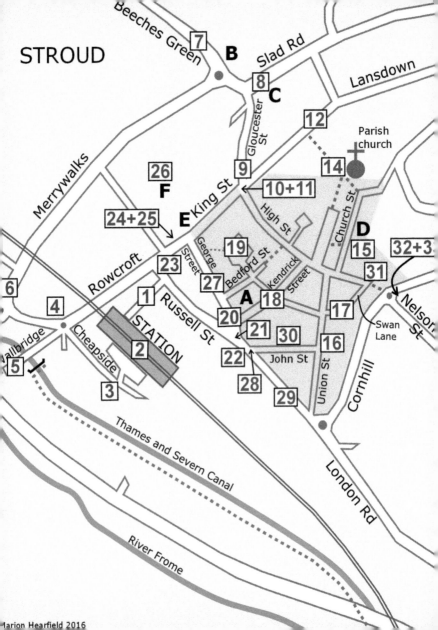

STROUD

Beeches Green

7

B

Slad Rd

Lansdown

8

C

Gloucester St

12

Parish church

Merrywalks

26

F

9

14

10+11

King St

High St

Church St

D

24+25

E

15

32+3

Rowcroft

23

George Street

19

Bedford St

Kendrick Street

31

6

27

A

17

4

1

20

18

Swan Lane

Nelson St

Wallbridge

Cheapside

Russell St

21

30

16

5

STATION

2

22

28

John St

Union St

Cornhill

3

29

London Rd

Thames and Severn Canal

River Frome

Marion Hearfield 2016

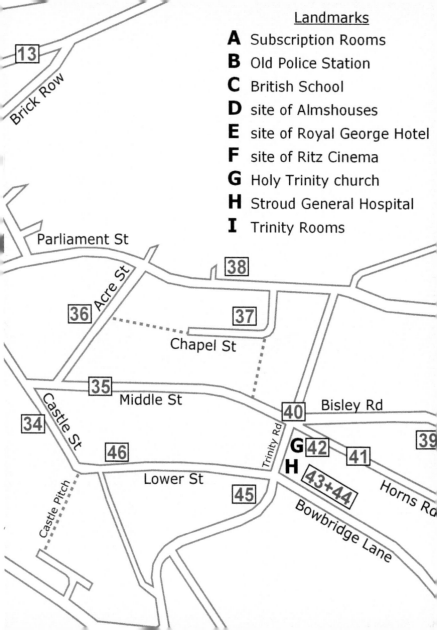

Landmarks

A Subscription Rooms
B Old Police Station
C British School
D site of Almshouses
E site of Royal George Hotel
F site of Ritz Cinema
G Holy Trinity church
H Stroud General Hospital
I Trinity Rooms

1. STATION ROAD

There can be few views of street life in Stroud to match this atmospheric picture. The flags and bunting may mark the coronation of George V and Queen Mary in 1911, or they may be for a visit of the County Agricultural Show, which came to Stroud in 1907 and again in 1912. Tradesmen and bystanders have all paused for photographer Henry Comley to capture the moment. In front of the Imperial Hotel note a station platform trolley with a box containing Henry Tate & Sons cube sugar.

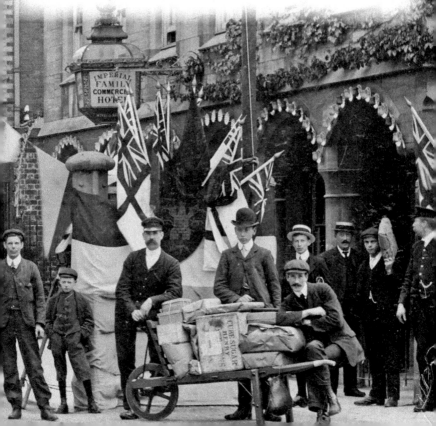

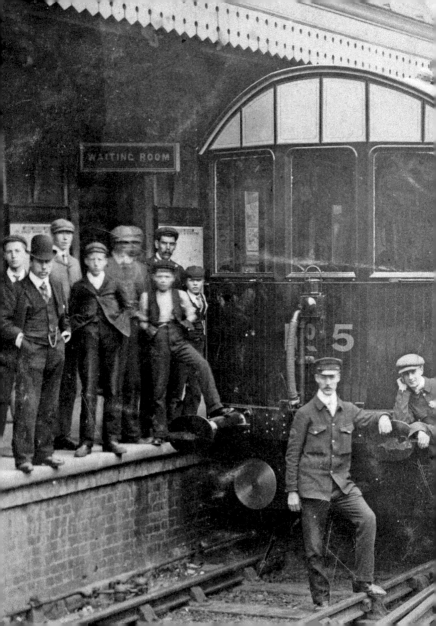

2. THE GREAT WESTERN RAILWAY RAILCAR

In October 1903 the Great Western Railway inaugurated a railcar system to run from Chalford, through Brimscombe and Stroud stations, to Stonehouse. Passengers would also be able to join the service at intermediate halts along the route. Unlike later railcars, which were carriages pulled by separate tank engines, the original railcars had an integral motor. This picture was probably taken on the inaugural day and shows car number 5 in Stroud GWR Station.

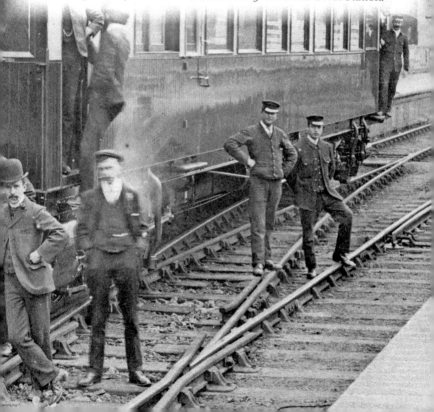

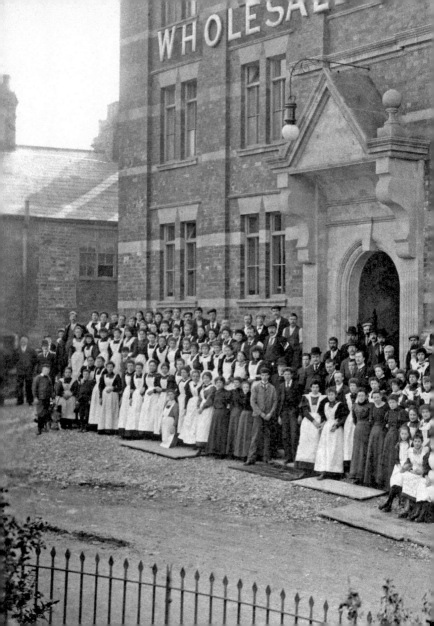

3. THE HILL PAUL BUILDING

This familiar Stroud landmark was purpose-built as a clothing factory in 1898. Just four years later, when the death of its founder was followed by the company's bankruptcy, it was bought and renamed as Hill Paul & Co. The building continued as a factory until 1989. After it had lain derelict for a decade or so, a local group of enthusiasts, the Hill Paul Regeneration Company, issued sufficient £500 shares for the structure to be saved and converted into flats. The renovation included a two-storey extension built on the roof. The photo shows the firm's workforce around 1902.

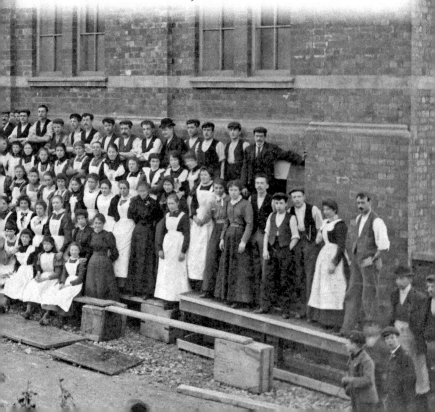

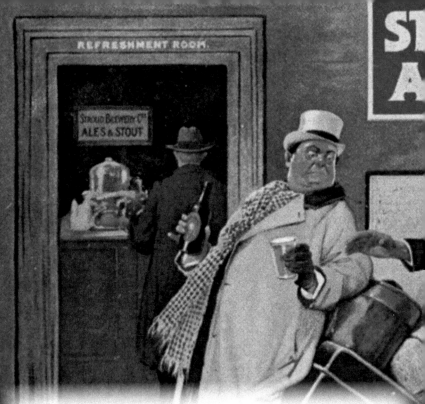

4. STROUD BREWERY

The old Stroud Brewery Company's buildings were at the lower end of Rowcroft. Owned in the early nineteenth century by Joseph Watts, whose grandson Joseph Watts Hallewell lived at Stratford Park Mansion, the Company was still in business in the 1950s (see inset photo). Pupils walking from the Downfield schools into Stroud remember the distinctive smell issuing from the Company's premises. Stroud Brewery's famous advertisement, which appeared before the First World War, was designed by the celebrated artist Lawson Wood.

"BY YOUR LEAVE, PLEASE!"

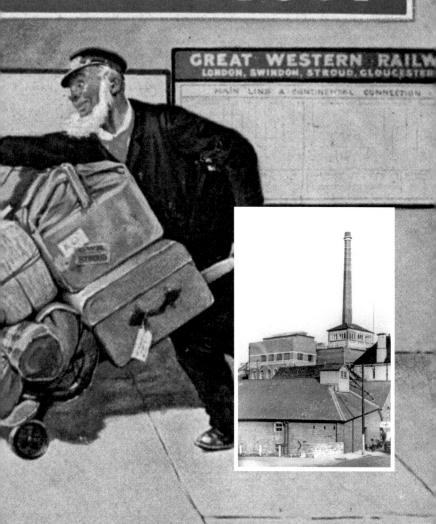

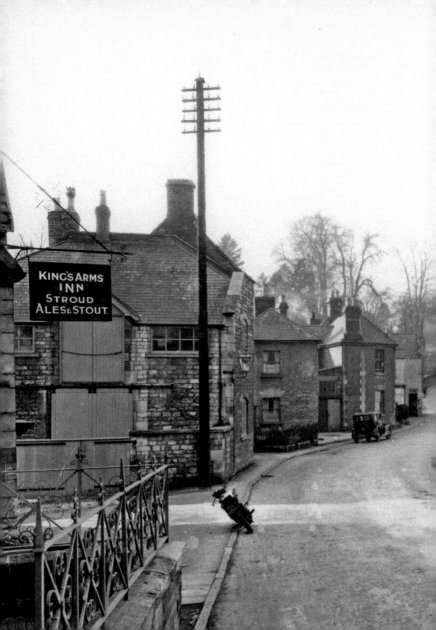

5. WALLBRIDGE

On the left is the inn sign for the King's Arms Inn, replaced following demolition by what are now the premises of Travis Perkins. The buildings beyond survive relatively unchanged. Occupied by Pratt's metalworking firm when this 1930s picture was taken by Stroud photographer Edwin Peckham, the further of the two properties on the right has gone, as has Cuttle's Mill House adjoining it. In the latter building, erected in 1714, were a pair of shell cupboards and a piece of eighteenth-century wallpaper, rescued by Lionel Walrond, then curator of Stroud Museum. These items are now on view in the Museum in the Park.

6. MERRYWALKS

Before the present, somewhat confusing, roundabout was installed, the junction of Merrywalks with Cainscross Road required just the single bollard shown here. The photo was taken almost exactly fifty years ago, at which time the Stroud Brewery buildings on the right were still standing, but have now been replaced by the premises and car park of what was, for many years, the Stroud Building Society headquarters. Ecotricity, the green utilities firm, now occupies the site.

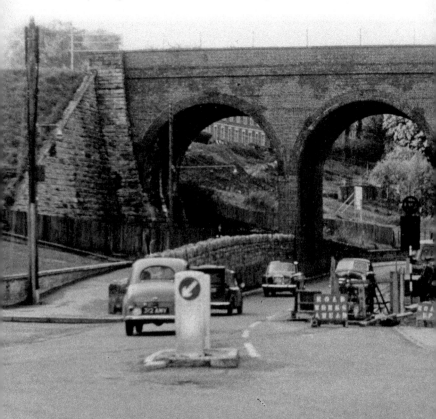

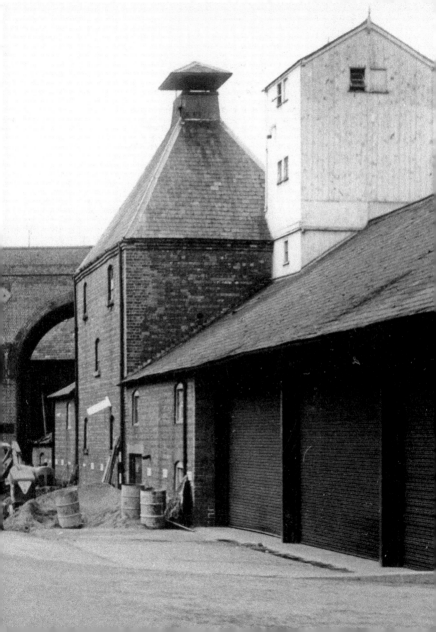

7. BADBROOK

This is an overexposed – possibly even double exposed – image, but important in the history of Stroud because of its age. Seen from Beeches Green, on the left is the old police station, in its original form before the Magistrates' Court was built onto it. To the right is a part of Badbrook House; in the centre is the Painswick House Inn, though clearly not the 1896 building which survives today. Nor are the late 1860s properties in Lansdown present. What confirms that this is indeed a very early image is the level of the parish church roof relative to its tower. This proves it to be a pre-1868 photograph.

8. FLOODS IN SLAD ROAD

The white painted building in the distance, Lloyd's chemist's shop, was among many properties badly affected by severe flooding in the summer of 2007, the latest of such occurrences. Here water levels reached the top of garage doors on the left side of the road. Subsequently drainage work was undertaken and, hopefully, has ensured that such scenes as this will not be possible in the future.

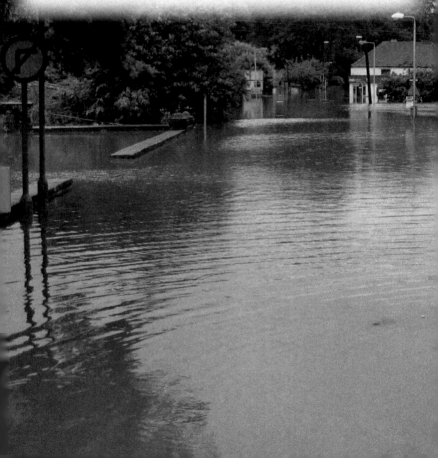

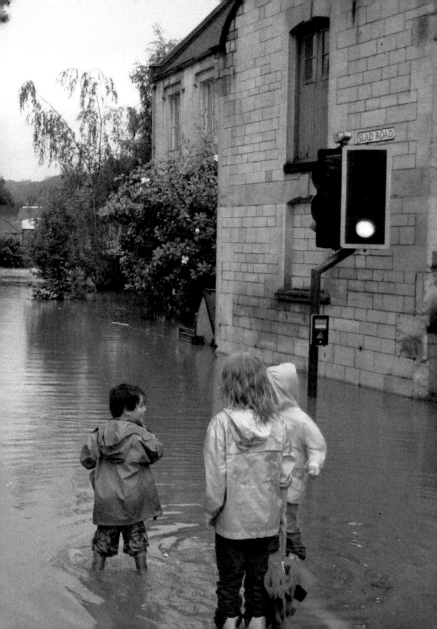

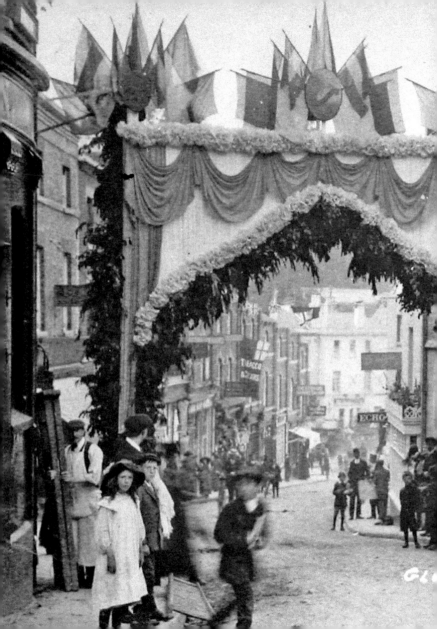

9. GLOUCESTER STREET

At the top of the street, decorated for the visit to Stroud of the County Agricultural Show in 1912, is the arch erected by local carpenter Philip Ford to celebrate that occasion. The oval panel that tops it contains the words 'SPEED THE PLOUGH'. The shops visible under the bunting and the flags represent a varied mix of trades, including two butchers. Nowadays eating establishments predominate on the left hand side when facing down Gloucester Street.

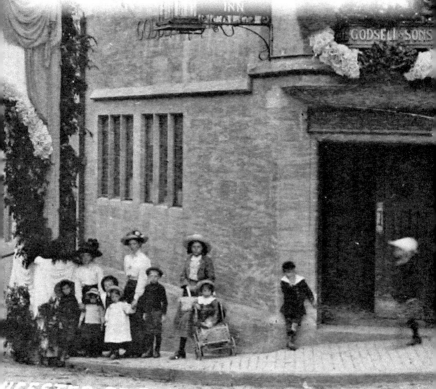

10. THE LOWER HIGH STREET

Until well after the Second World War, two-way traffic operated in the four streets which meet at this point. This necessitated a policeman being present – a feature of Stroud well remembered by older people. Note the traffic signs and, of course, the absence of yellow lines.

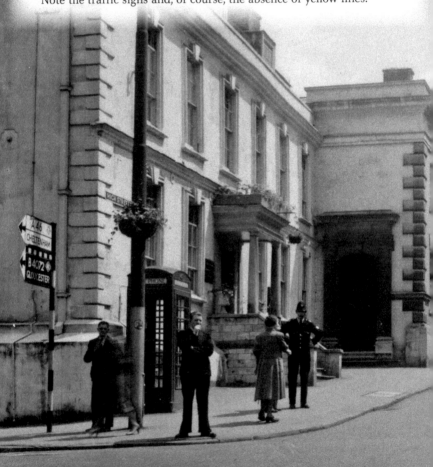

High St, Stroud.

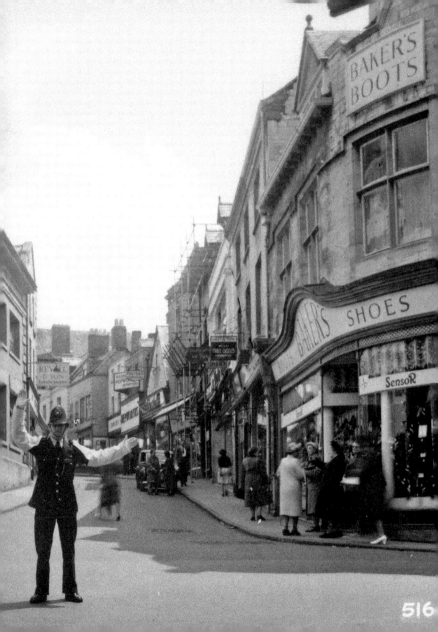

516

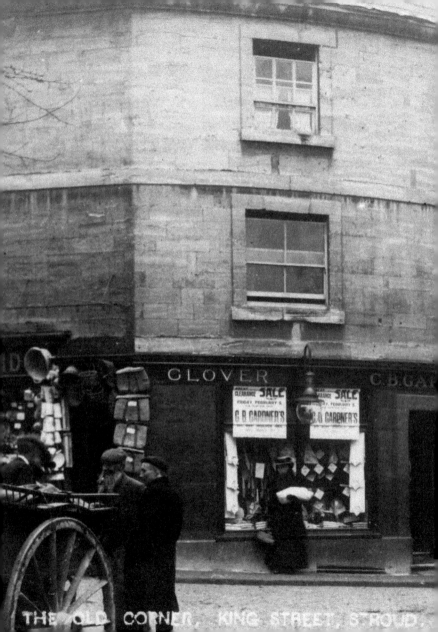

THE OLD CORNER, KING STREET, STROUD.

11. THE CORNER OF KING STREET WITH LOWER HIGH STREET

In 1904 the building that housed Charles Burghope Gardner's hat and glove shop was due to be demolished and young photographer William Lee, working from his father's stationer's shop at the top of the High Street, evidently felt he should record what it looked like. Hence the postcard's caption 'the old corner'. Clearance sale posters in Gardner's windows foreshadow the firm's move to Gloucester Street while rebuilding took place.

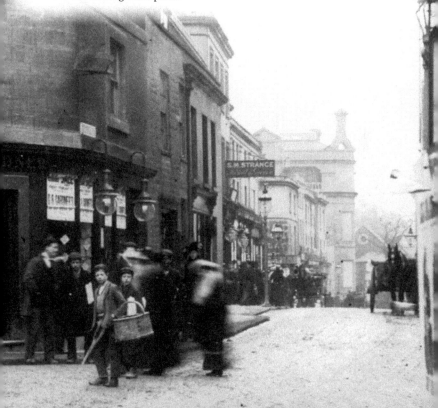

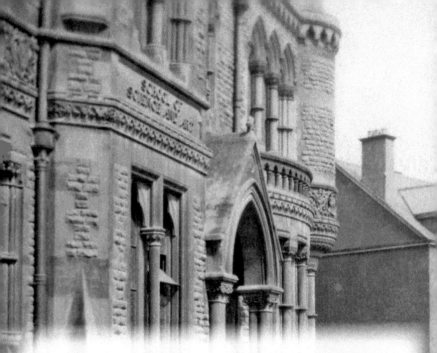

12. THE SCHOOL OF SCIENCE AND ART

This fine building – more impressive, one would have to say, from the front than the back – was erected at the very start of the twentieth century to complete an earlier School of Art opened in 1893, itself a successor to a mid-Victorian one in the High Street. For much of its history it housed Stroud Museum, which still retains the use of several rooms for storage. Immediately beyond it on the left is Locking Hill, now considerably wider than shown here. The old Vicarage garden on the right is the site of the present library. On the lower side of the School of Science and Art is a lane housing the garage for S. M. Strange's grocery firm (inset).

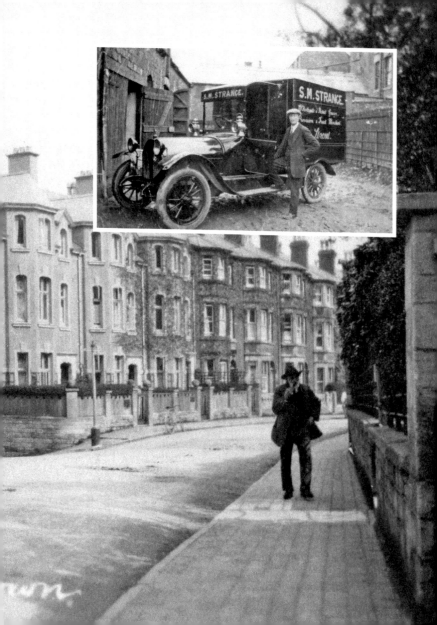

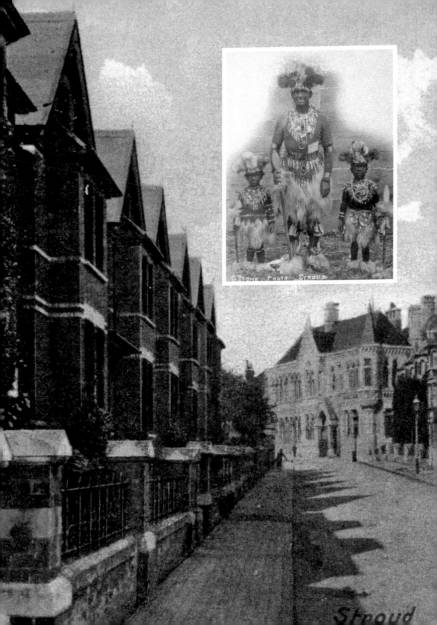

G. STONE PHOTO STROUD.

Stroud

13. LANSDOWN

This coloured postcard dates from around 1910 and is of interest for two reasons. Firstly, note the complete absence of any kind of traffic, or the road markings that are so prominent today. Secondly, the picture demonstrates how popular was the practice a century ago of covering buildings with creeper. Just off shot to the left of this scene stood Spot Walker's cinema – the Electric Photo Playhouse. In order to attract customers this enterprising showman would dress himself in African native costume and parade around the town accompanied by two similarly dressed young assistants he referred to as 'Timbuc One and Timbuc Two'.

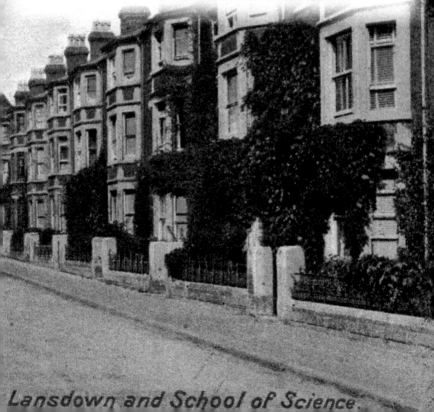

Lansdown and School of Science.

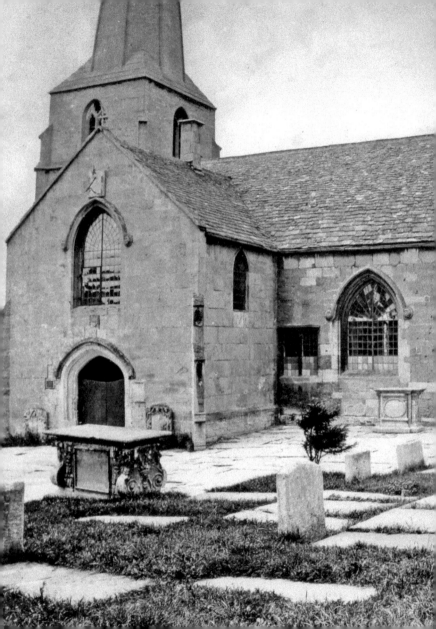

14. STROUD PARISH CHURCH

Originally a portion of Bisley Parish, in 1304 Stroud was awarded the status of a separate ecclesiastical unit. By the mid-nineteenth century, even with the addition of galleries – the external access steps to which are visible on this fine 1860s photo – the church had become hopelessly inadequate to seat those attending services. In 1868, all but the tower and spire – built by the Whittington family – was demolished and replaced by the much larger building with which we are familiar today.

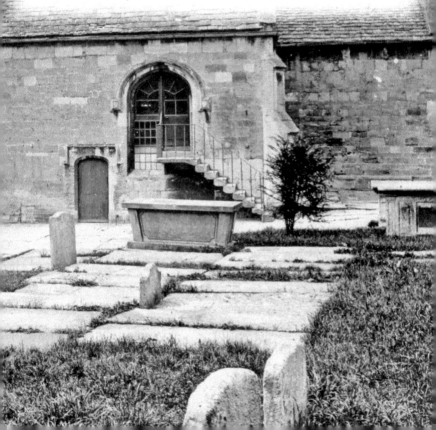

15. CHURCH STREET

On the left of this photo is the back wall of the Old Town Hall, erected around 1590. In the distance is the former Rodney House, put up in 1635. In 1912 it became the Parish Church Vicarage and is now a home for the elderly. On the right are the almshouses which survived until after the last war. It does seem a shame that such attractive buildings should have been allowed to disappear, to be replaced by nothing more special than a few car-parking spaces.

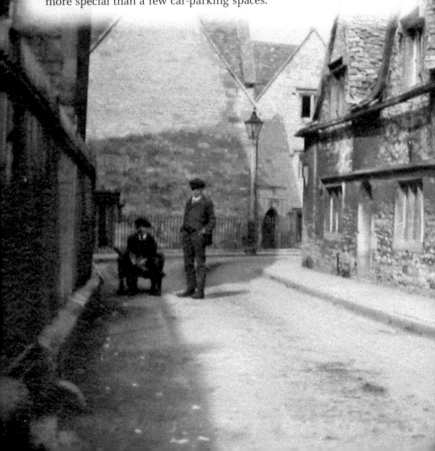

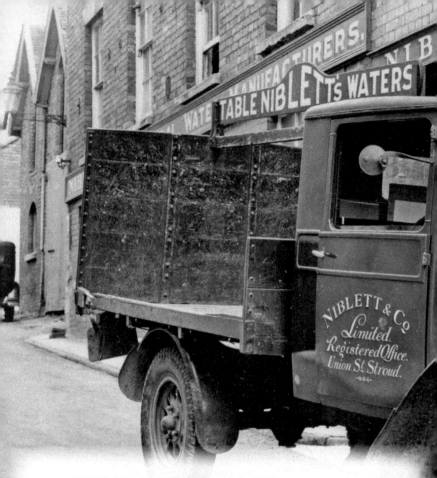

16. UNION STREET

Where the nationally famous Farmers' Market now takes place was once the site of Niblett's Mineral Water factory. The advertisement with its rather flattering engraving of the premises, was taken from a 1902 Stroud Directory. The photo of Niblett's lorry dates from the 1930s.

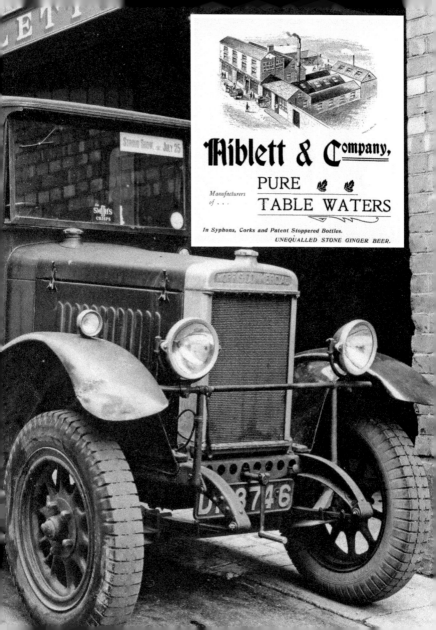

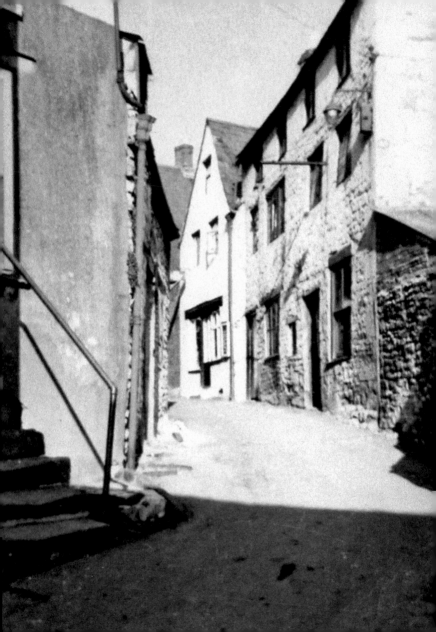

17. SWAN LANE

This curving road leads from the Swan Inn in Union Street to the High Street. Many remember it housing the tinsmith's business of W. H. Knight, pictured *c.* 1915, his family firm traceable in Stroud back to the early nineteenth century. When properties in Swan Lane were demolished, Mr Knight – known to all as Billy – moved his workshop to Bath Street and, remarkably, was still crafting orders in metal when in his nineties.

18. KENDRICK STREET

This street was cut through in 1871 in order to connect High Street with George Street. The building with the pilasters and capitals, partially visible on the far right of the photo, has one of Stroud's best surviving Victorian shop fronts and has been a baker's for more than a century. In the 1890s it housed the firm of R. T. Smith, carriers for the Great Western Railway. The sign for Oliver's shoe shop projects further along the street.

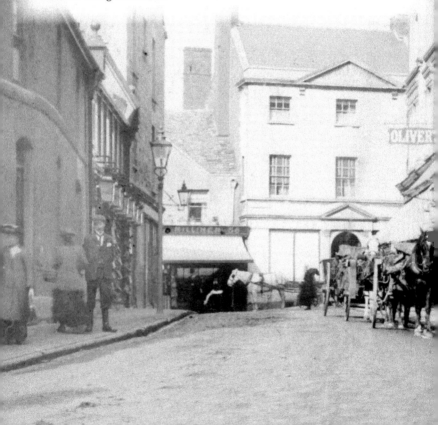

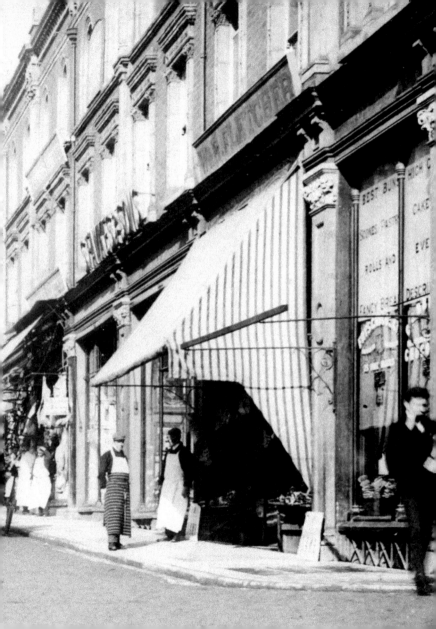

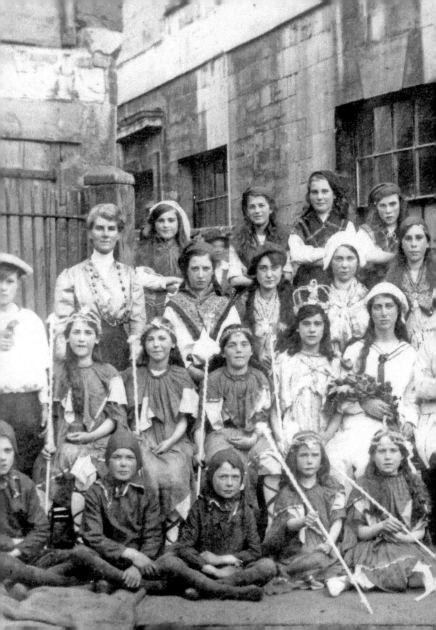

19. BEDFORD STREET CONGREGATIONAL CHAPEL

An offshoot of the Old Chapel at the top of Stroud, this neoclassical building was put up in 1837. Both the author and his grandfather were married there, in 1966 and 1901 respectively. Taken in what is now Fawkes' Yard, the image dates from around 1920 and records some chapel drama on a nautical theme. Characters – all female – named on the reverse of the picture, include Captain Barnacle, Prince Submarine and King Torpedo. The author's aunt, Nellie Beard, is fourth from the right, second row back.

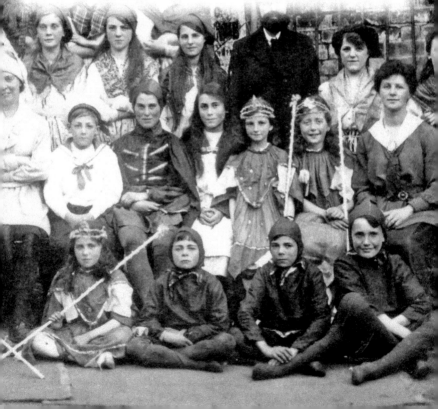

20. THE SUBSCRIPTION ROOMS

In 1832 well-to-do local people were invited to purchase £50 shares in order to create a new civic building for Stroud; names of subscribers are preserved in a surviving bank book. The Rooms opened in 1834, since when substantial renovations took place in 1869, 1926, 1961 and around the time of the Millennium. In the photograph, which records Liberal C. P. Allen's 1900 election victory over his Conservative opponent C. E. Cripps, note the cabmen's shelter and the two Crimean War cannons.

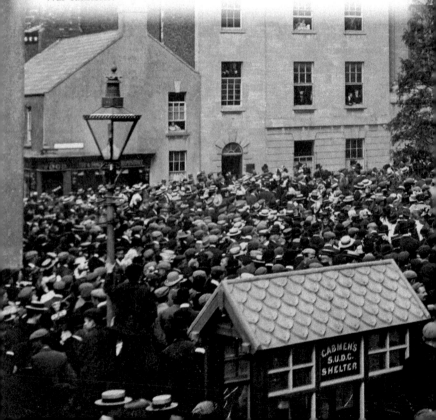

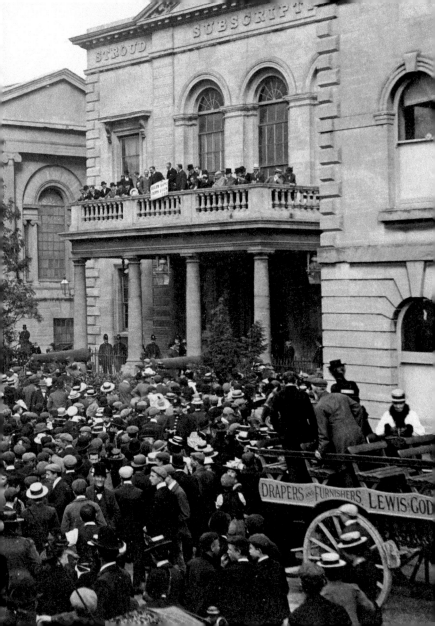

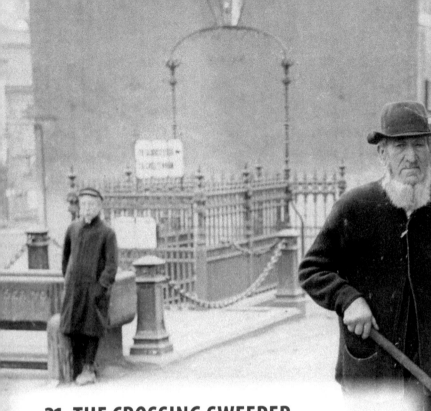

21. THE CROSSING SWEEPER

No doubt earning a few pennies in his old age, the crossing sweeper stands in the road near where Bateman's sports and toyshop is today. The Edwardian horse bus (inset) shows that corner before the insertion of plate-glass windows. To the left in the main photo is the horse trough used by the animals which pulled the buses. Within the railings, a flight of steps led down to a gentlemen's underground toilet. Nowadays Sims' clock stands exactly on this spot. The toilet below, though no longer accessible, apparently still exists.

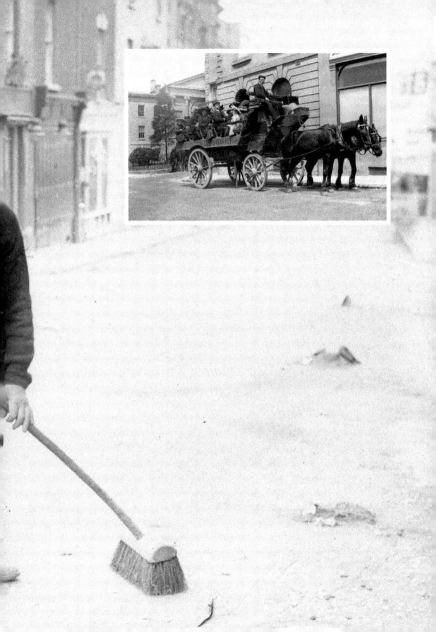

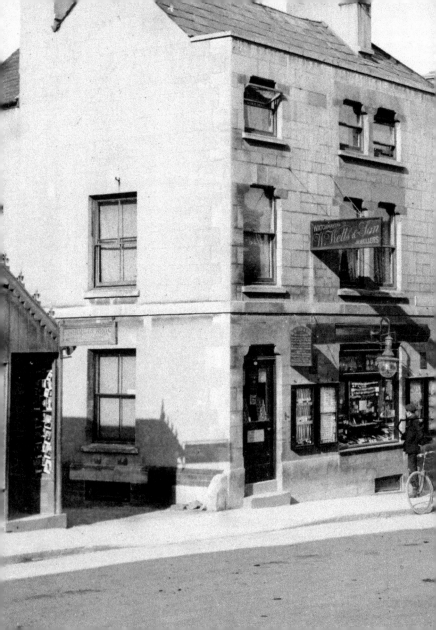

22. RUSSELL STREET, TOP END

The wooden building on the left, long gone, was Mark Merrett's photography studio in Edwardian times and, later, the premises of Percy Freebury's Art Memorial Company. Next to it is Walter Wells the jeweller's, then the premises of Sidney Pearce (the author's great-uncle), saddler and purveyor of leather goods (it is just possible to pick out the horse's head fixed to the wall). Further down the street is the Wicliffe Motor Company's garage. Beyond that is the post office, housed in what is today the Lord John pub.

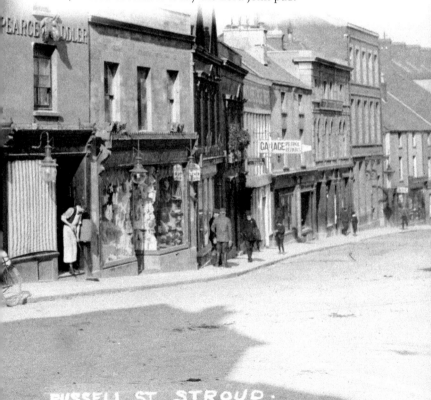

RUSSELL ST STROUD.

23. GODFREY'S DRAPERY STORE

On the corner of Russell Street and King Street Parade was the draper's premises of a Mr Godfrey. The firm later became Lewis and Godfrey's, familiar to older generations of Stroud people. This image is a rare one, since it well pre-dates the era of picture postcards and shows the shop decorated to mark the 1892 visit to Stroud of the County Agricultural Show. With its bunting, flags and Chinese lanterns it illustrates the enthusiasm of tradesmen to compete with each other in celebrating both local and national events.

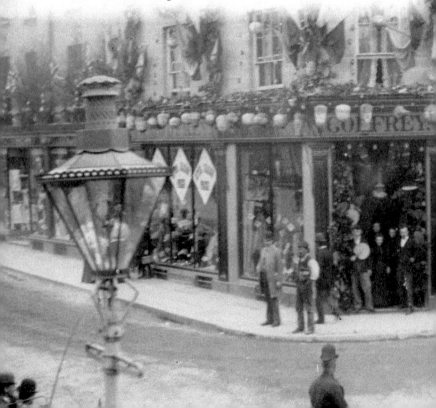

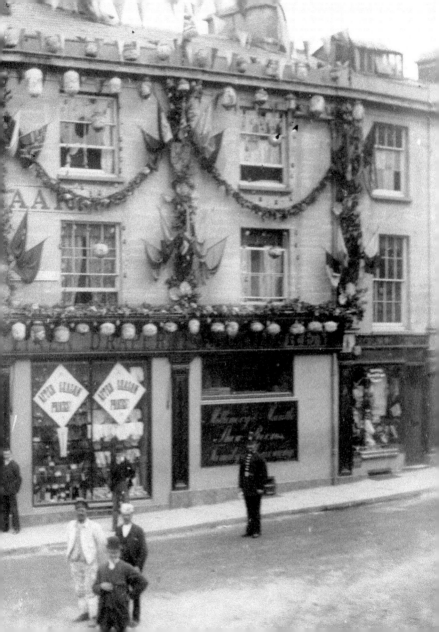

24. THE ROYAL GEORGE HOTEL

Taken during the 1907 visit of the County Agricultural Show, Stroud's principal hotel, The Royal George, is seen in all its decorated finery. Sadly it ceased trading just a few years later when the top two floors were converted into the Picture House cinema. Joining it to Coley's, the chemist's opposite, is one of the five arches put up in the town on that occasion.

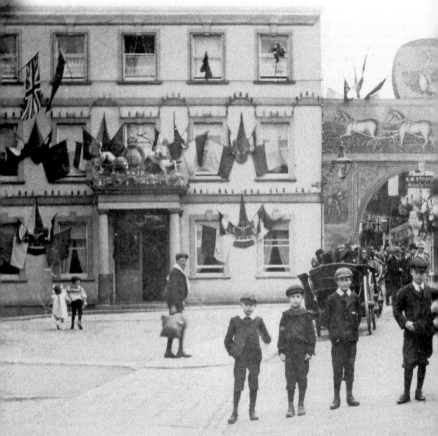

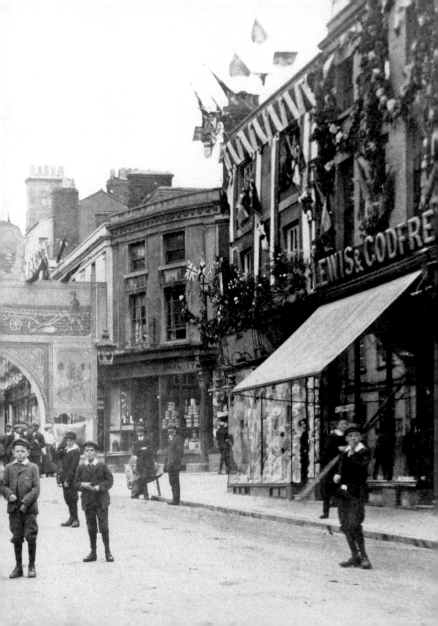

25. WOOLWORTH'S

What was later to become Woolworth's – now Poundland – is seen here housing an ironmonger's and furniture store on the ground floor. The original design of the building included the Victoria Rooms on the first floor – a venue where events were frequently held in the nineteenth century. When this picture was taken the Rooms had been divided vertically and incorporated into the shops below. However, what makes this photo so interesting is the display put on by local firemen. Several brigades are represented, that from Minchinhampton being conspicuous by the men's white trousers – surely a somewhat impractical colour for firemen? The right third of the building seen in the photo survives today.

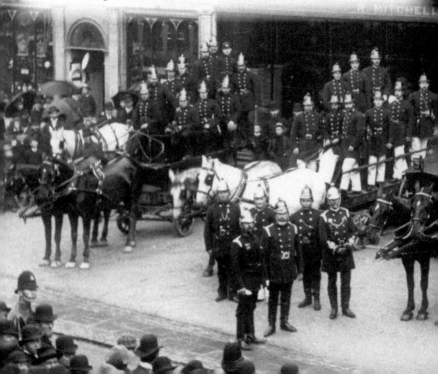

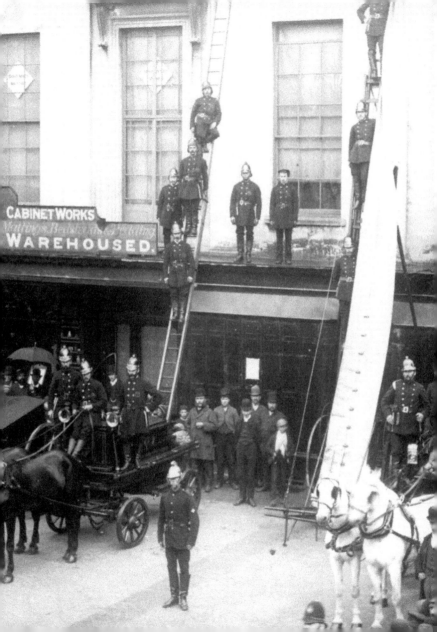

26. THE RITZ CINEMA

Opened around 1938 and built in art deco style, this was one of the two cinemas then available in Stroud. The other was the Gaumont in London Road. The Ritz foyer was usually presided over by a portly, friendly gentleman called Mr Walters. Above the cinema was a restaurant. The Ritz burnt down spectacularly in 1961 – the author watched its sad demise. The inferno was hot enough to bend girders, yet a cat survived and, next day, appeared wet, scared, but little the worse. The Merrywalks shopping precinct was later built on the site of the Ritz.

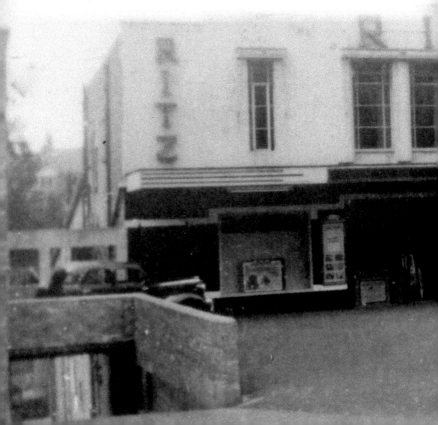

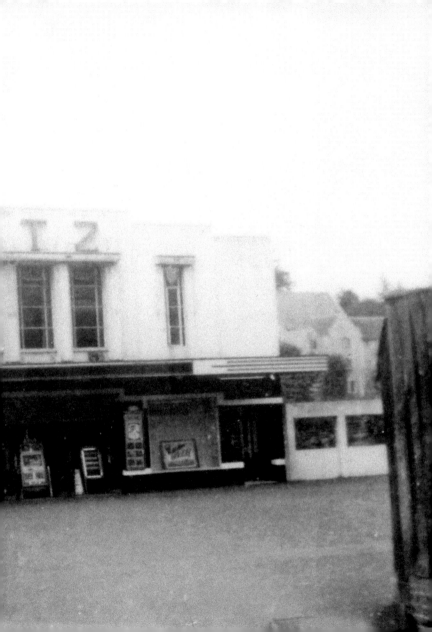

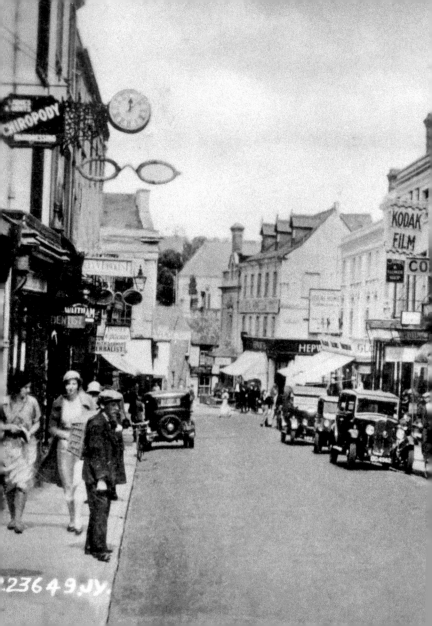

27. GEORGE STREET

Around 1930, when this postcard was produced, there was two-way traffic in George Street. Note the giant spectacles which project above an optician's shop on the left. On the right, past the clutter of bicycles, Collins' stationery and photographic business can be seen. In the distance is the Picture House cinema, with Hepworth's on the ground floor beneath it. In 1935 this building was replaced by Burton's the tailor's and is now a chemist's.

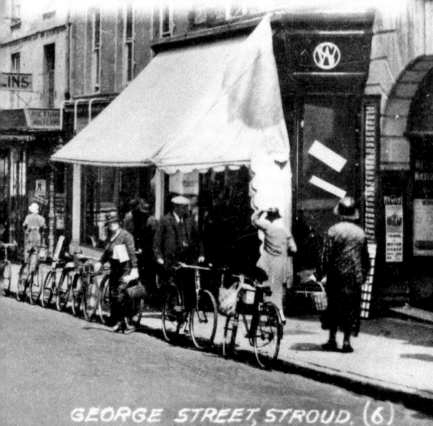

GEORGE STREET, STROUD. (6)

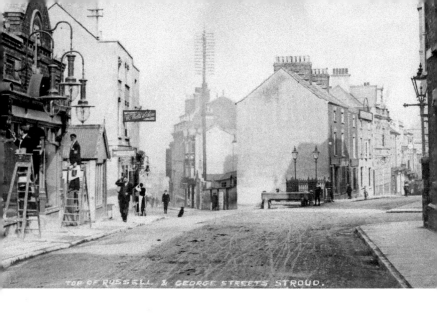

TOP OF RUSSELL & GEORGE STREETS STROUD.

28. LONDON ROAD, FIRST VIEW

At various times the building on the left housed a garage and the Empire Cinema, the latter reconstructed in 1935 as the Gaumont. Note the splendid gas lamps. Just visible by the one on the far right is part of Isaac Lendon's coach works. Telegraph poles in pictures taken a century ago seem unexpectedly prominent, while un-metalled roads in town centres also come as a surprise.

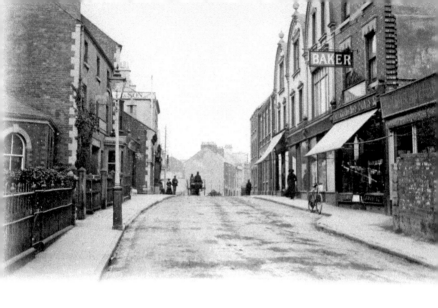

29. LONDON ROAD, SECOND VIEW

The photographer of this postcard of around 1905 stood just a few yards further away from the town centre and the picture shows more that has since changed. On the right the three curved gables have gone, as has the bend in the kerb. Baker's shop, with its sign for 'PAPERHANGINGS, PAINTS ETC.' later moved to premises across the street; the red-brick buildings on the left were replaced in the 1950s. By the head of the gas lamp, a sign in the shape of a horse advertises the smithy of Henry Pearce, brother of Sidney whose shop was in Russell Street. These two brothers were great-uncles of the author.

30. JOHN STREET BAPTIST CHAPEL

In 1912 the chapel's organ was rebuilt by the local firm of Liddiatt. This photo celebrates the occasion. At the instrument is Miss Ethel Brinkworth, who ran a small private school called The Birches in Folly Lane. She held the position of organist at the chapel for half a century, though her sight became defective towards the end of this period. However, Miss Brinkworth knew all the hymns by heart and, provided the author's mother, Vera Beard, sat close by and nudged her gently to let her know that the last verse of each hymn had arrived, she was still able to continue to accompany the services.

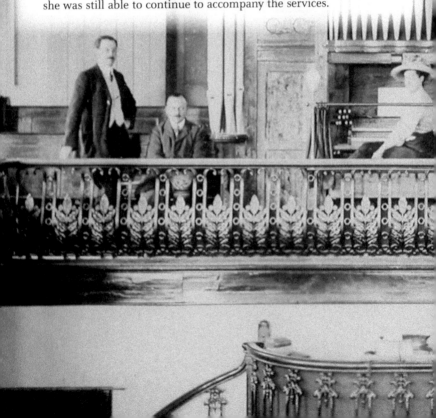

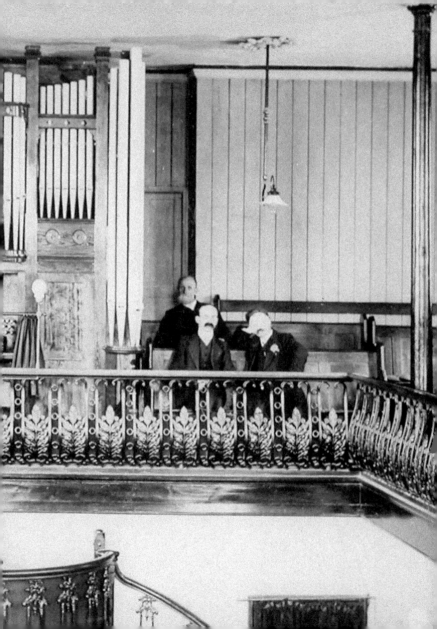

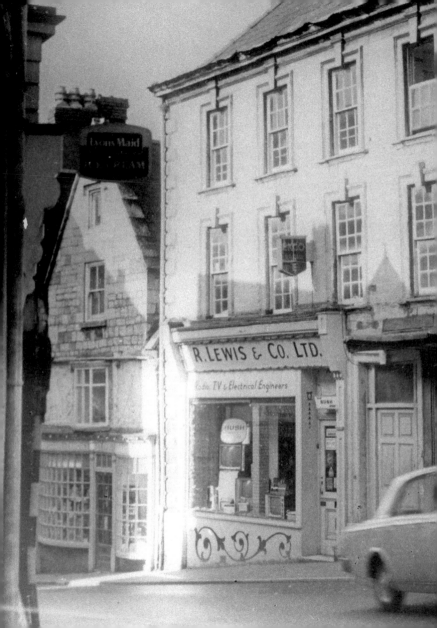

31. EXCHANGE BUILDINGS

The site of this impressive structure can be pinpointed from its position next to the bay window of Mrs Barsby's sweet shop, surviving today as an antiques and curios business. Exchange Buildings were sadly lost in the 1960s. At that time Walter Collins' printing concern was housed in the nearby courtyard. As the picture shows, fronting the High Street was R. Lewis's electrical premises. In the nineteenth-century part of Corn Exchange Buildings had been the home of successful Stroud trader William Cowle.

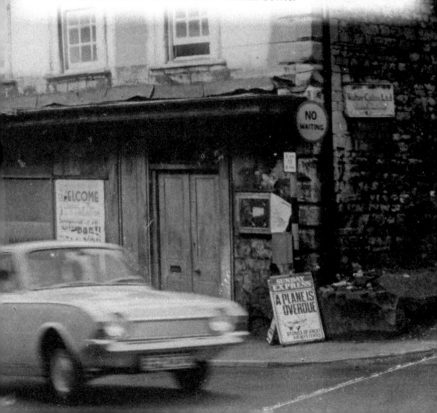

WHOLESALE

DIRECT IMPORTER

FLORIST AND SEEDSMAN.

ENGLISH & FOREIGN FRUITERER.

J. BRADSHAW

CHEAPEST SH

32. BRADSHAW'S

It is possible to stand exactly where Bradshaw's once was – if you are on the zebra crossing near the top of the High Street. These premises and other adjoining shops were demolished when Cornhill was cut through. Bradshaw's advertised itself as the 'cheapest shop in the town', yet it had an oyster bar and a machine for peeling potatoes. The firm also sold ice, flowers and seeds, as well as providing funeral wreaths and crosses.

MERCHANT.

WREATHS from 3/6 & CROSSES.

WENHAM AND OTHER ICE IN STOCK.

POTATOES PEELED BY MACHINERY.
FISH THOROUGHLY CLEANED.

BRADSHAW

37

IN THE TOWN

J. BRADSHAW.

FISH AND OYSTER BAR

C C M C

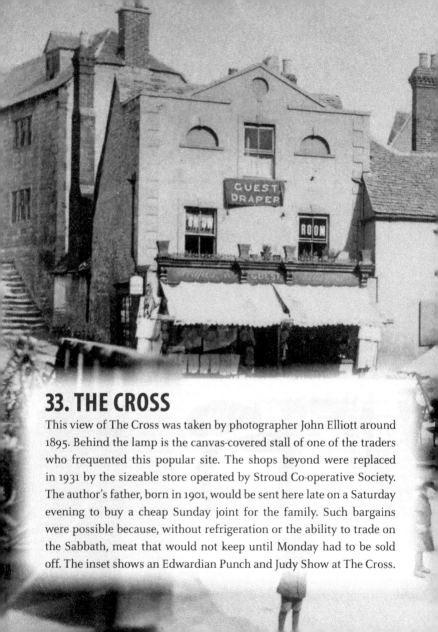

33. THE CROSS

This view of The Cross was taken by photographer John Elliott around 1895. Behind the lamp is the canvas-covered stall of one of the traders who frequented this popular site. The shops beyond were replaced in 1931 by the sizeable store operated by Stroud Co-operative Society. The author's father, born in 1901, would be sent here late on a Saturday evening to buy a cheap Sunday joint for the family. Such bargains were possible because, without refrigeration or the ability to trade on the Sabbath, meat that would not keep until Monday had to be sold off. The inset shows an Edwardian Punch and Judy Show at The Cross.

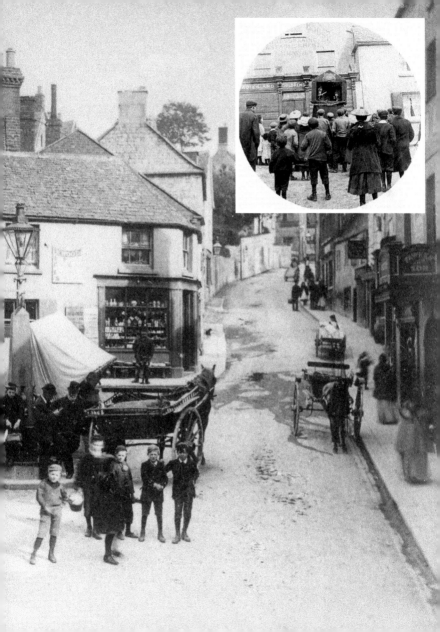

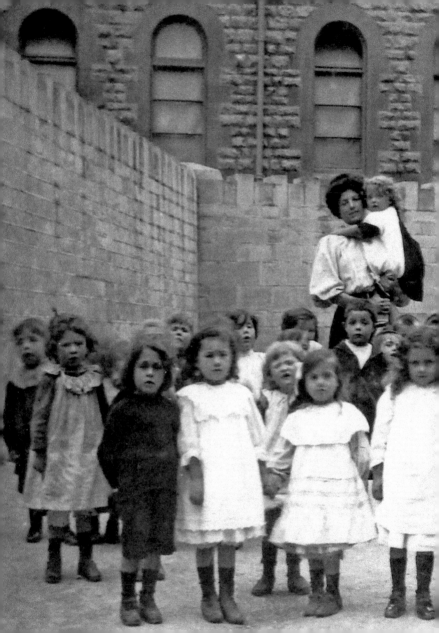

34. CASTLE STREET

A class from Castle Street School – now Stroud Valley Community Primary School – is pictured here just over a century ago. The teacher, reassuring one of her youngest pupils, is Ella Peer, a member of the family that ran Orchard & Peer's building firm at Bowbridge. The small enclosed area in which the children stand is located at the side of the Methodist Chapel, which is seen in the background.

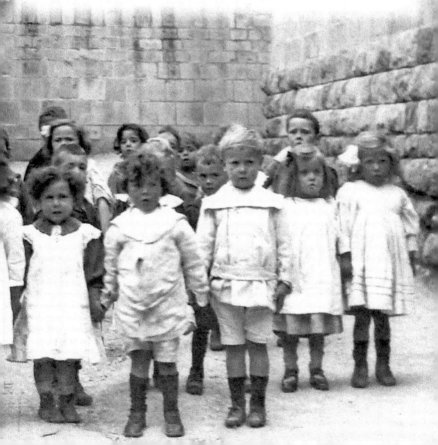

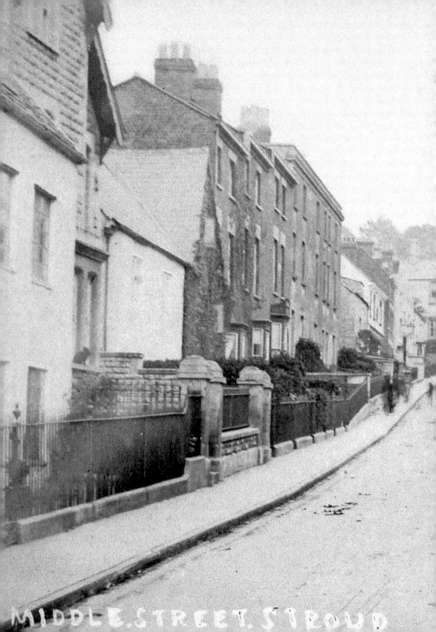

MIDDLE.STREET.STROUD

35. MIDDLE STREET

This is one of the older parts of the town, as several surviving buildings attest. By 1910, when the picture was taken by Bisley photographer Frederick Major, Victorian infill had seen the construction of many properties along this street. In Edwardian days the terrace on the right contained several shops, one of which still existed when the author delivered bananas to it on a summer holiday job in 1963. The walled area beyond was, for many years, Sutton's plant and seed shop.

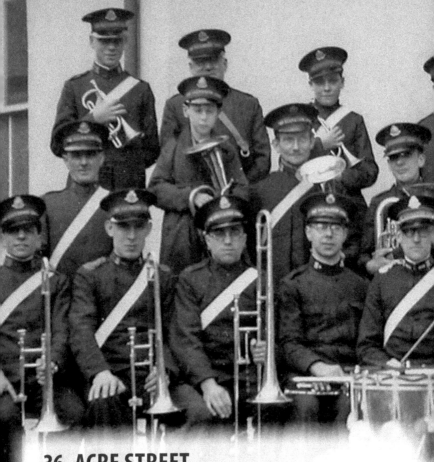

36. ACRE STREET

On the west side of Acre Street stands the Salvation Army Citadel. This 1938 picture shows its band. The building was actually erected by the Methodists in 1763 and Wesley himself is recorded as preaching in it every year from 1765 until his death in 1791. In 1876 a new Methodist chapel was built in Castle Street and, by 1891, the Acre Street premises were occupied by the Salvation Army.

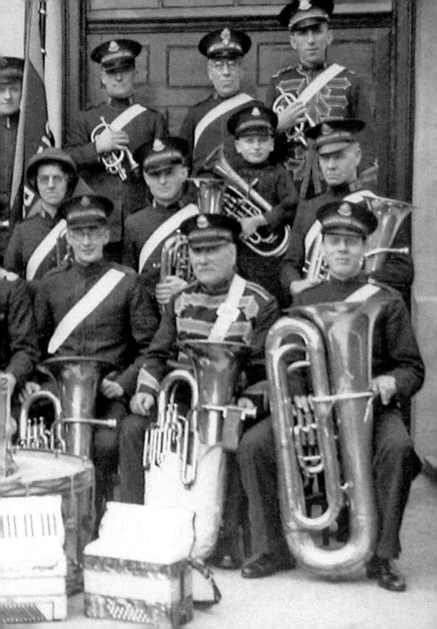

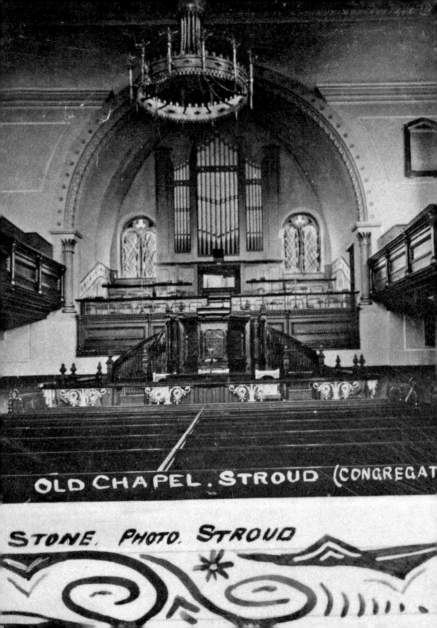

OLD CHAPEL. STROUD (CONGREGAT

STONE. PHOTO. STROUD

37. CHAPEL STREET

The Old Chapel was built around 1705 by Congregationalists who had previously met in a barn in Silver Street – now Parliament Street. After Bedford Street Chapel was put up in the town centre in 1837, the two congregations continued to operate separately until finally uniting in 1970. The Old Chapel was demolished soon afterwards. Some of its monuments and brasses (plus a spinal vertebra of its founder) were rescued for Stroud Museum. On the back of this 1905 postcard a lady called Bessie reports that 'the children are alright, but Baby was throwing all he could into the bath last night'.

ONAL)

MINISTER. REV D.A.DAVIES

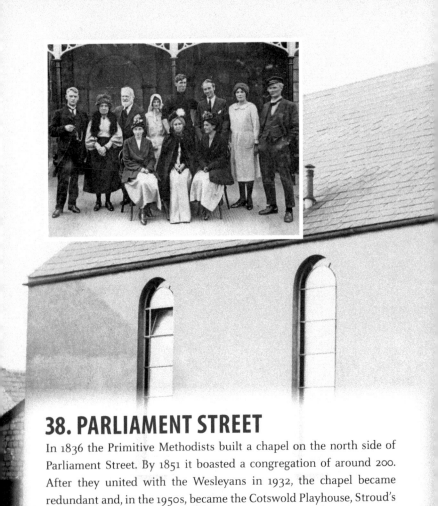

38. PARLIAMENT STREET

In 1836 the Primitive Methodists built a chapel on the north side of Parliament Street. By 1851 it boasted a congregation of around 200. After they united with the Wesleyans in 1932, the chapel became redundant and, in the 1950s, became the Cotswold Playhouse, Stroud's own theatre. This picture of it is Edwardian. The later photo shows the cast of a 1930s production of 'Yellow Sands' in front of St Laurence Church Hall, where the group then performed.

STROUD PRIMITIVE METHODIST CHAPEL

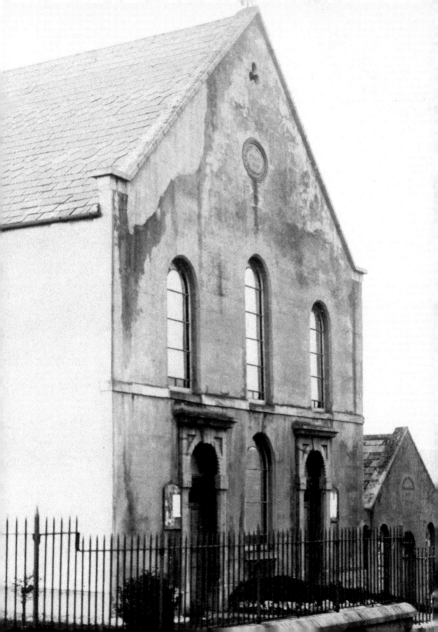

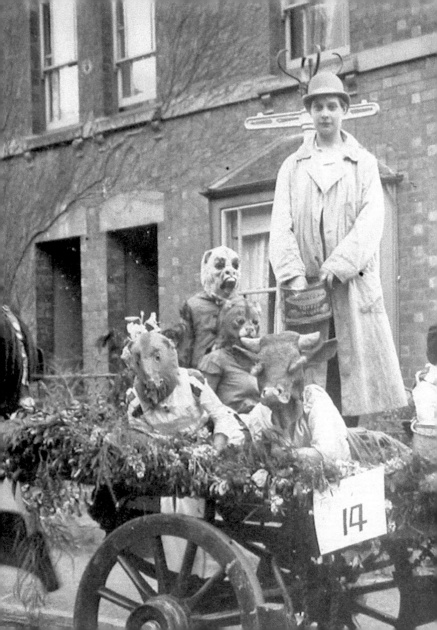

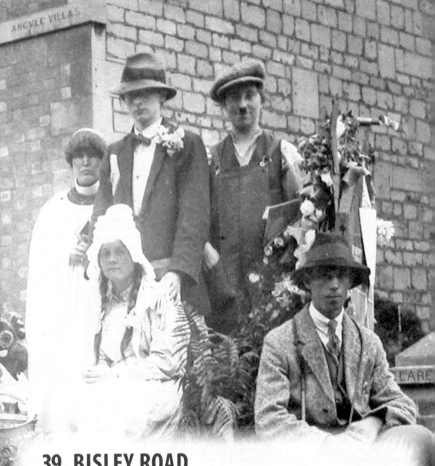

39. BISLEY ROAD

Originally known as Cemetery Road, Bisley Road was developed in the late nineteenth century, following the 1873 sale to William Cowle of what had been for 400 years the Arundell's Field Estate. The road was also a frequently chosen venue for marshalling carnival floats, as seen here. The picture is thought to have been taken around 1930, though it is unclear exactly what theme the participants represent.

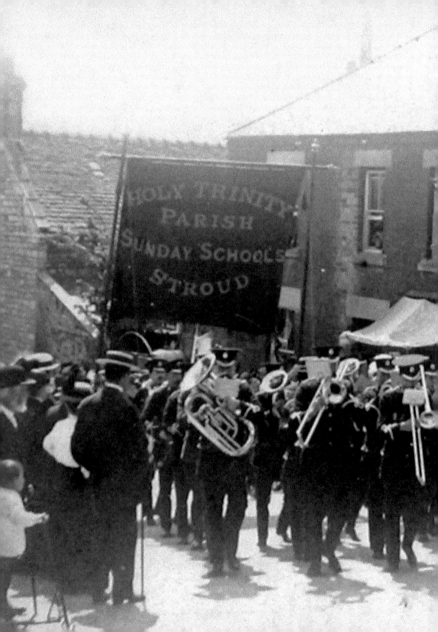

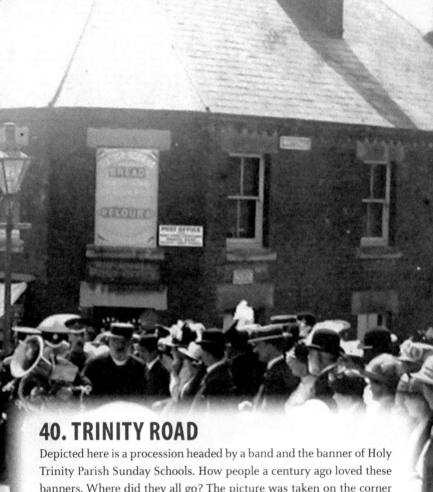

40. TRINITY ROAD

Depicted here is a procession headed by a band and the banner of Holy Trinity Parish Sunday Schools. How people a century ago loved these banners. Where did they all go? The picture was taken on the corner of Trinity Road with Whitehall. The building in the background was not only a 'bakery and potato stores', it was also Whitehall Post Office, in its original location before moving to the top of Middle Street, its site when it closed only a few years ago.

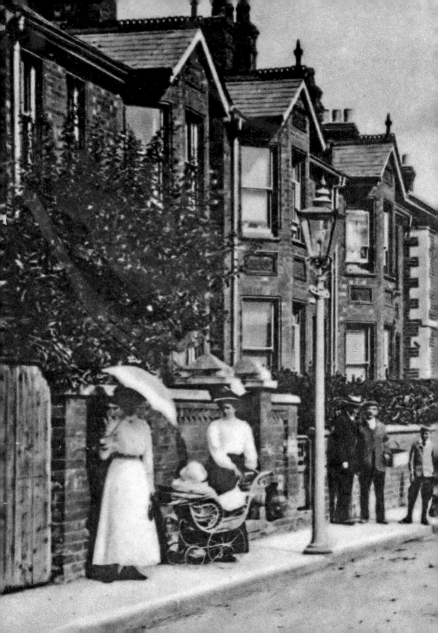

41. HORNS ROAD

As was the case with Lansdown, Horns Road seems strange without its familiar row of parked cars. This picture is by Frederick Major and is in the form of a printed postcard, rather than a real photographic one – hence the slightly fuzzy definition. However, the people with the parasol and the expensive wickerwork pram give it life and it consequently seemed preferable to better focused, but less atmospheric pictures.

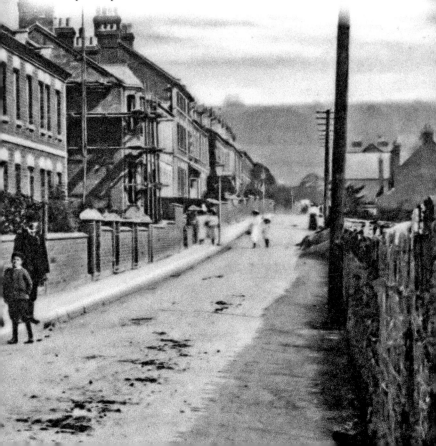

42. HOLY TRINITY CHURCH

Holy Trinity was erected in 1839 and consecrated the following year. The cost of its construction was borne partly by subscription. As the Edwardian picture shows, it originally had twin turrets at its western end. The inset photo, of roughly the same date, reveals its extensive interior wall paintings, now sadly covered over.

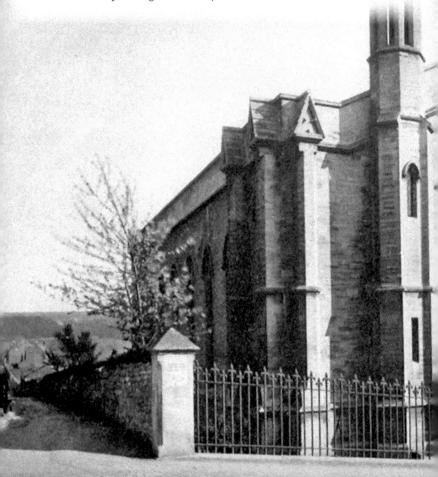

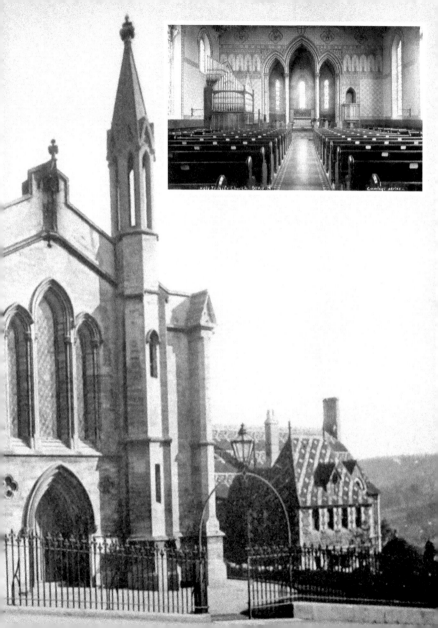

Holy Trinity Church, Stroud.

43. STROUD HOSPITAL

By 1873 the old dispensary, next to Bedford Street Chapel in the town centre, was deemed inadequate for the needs of Stroud's growing population, so the present building was erected in Trinity Road. Note the hospital's western end, also seen in the previous photograph, later replaced by the Peace Wing (see the next page). Also note William Cowle's observatory at the extreme right of the picture, on the corner of Field Road with Bowbridge Lane.

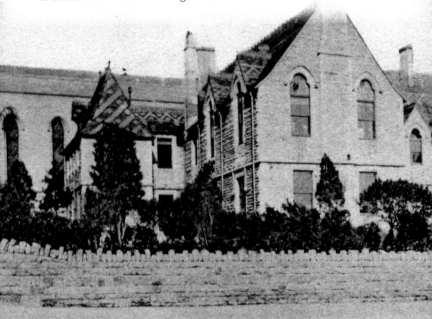

Hospital, Stroud.

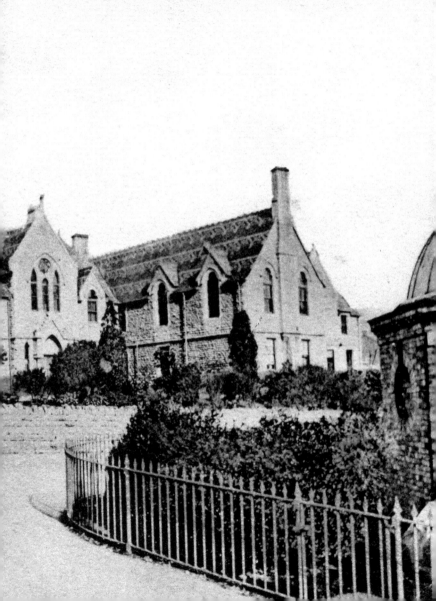

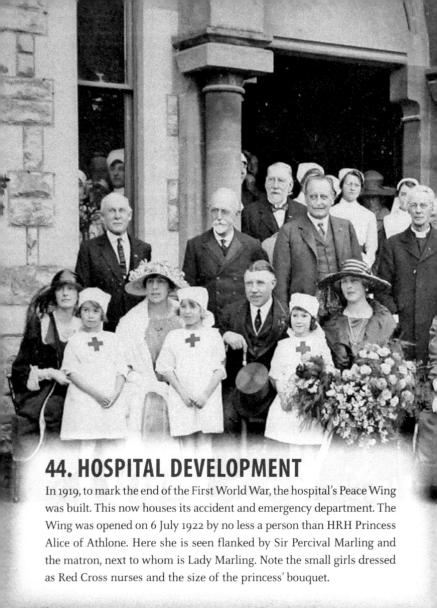

44. HOSPITAL DEVELOPMENT

In 1919, to mark the end of the First World War, the hospital's Peace Wing was built. This now houses its accident and emergency department. The Wing was opened on 6 July 1922 by no less a person than HRH Princess Alice of Athlone. Here she is seen flanked by Sir Percival Marling and the matron, next to whom is Lady Marling. Note the small girls dressed as Red Cross nurses and the size of the princess' bouquet.

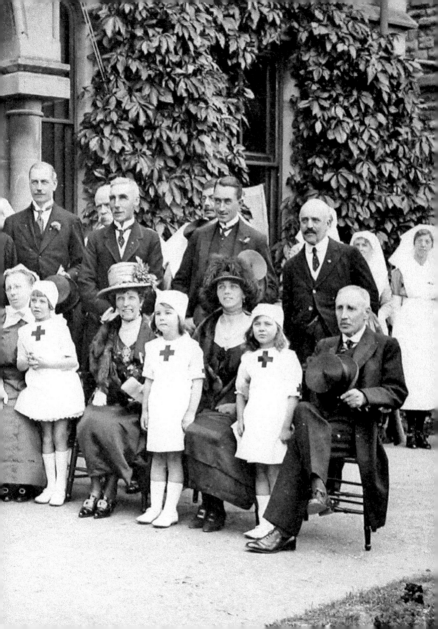

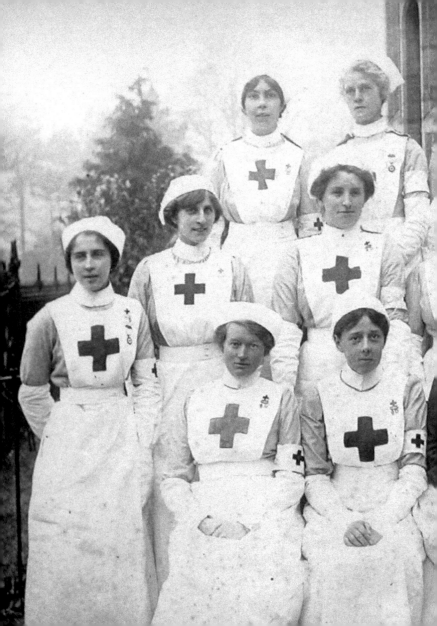

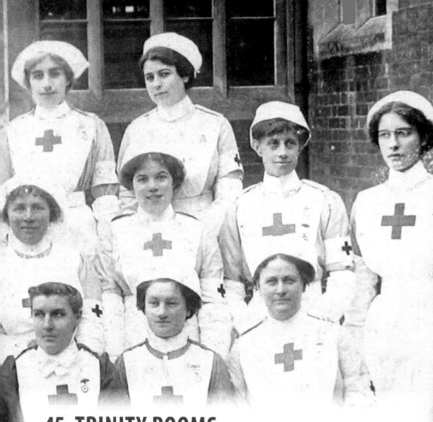

45. TRINITY ROOMS

During the First World War the Trinity Rooms, still a well-used venue for church and other events today, served as a Voluntary Aid Detachment Hospital. Like other similar institutions at Standish and Chestnut Hill in Nailsworth, it was intended to cater for wounded servicemen unable to be accommodated in regular hospitals. It was staffed mainly by the daughters of well-to-do families – shades of the TV drama, *Downton Abbey*... It treated 1,015 patients from 28 October 1914 until its closure on 3 January 1919.

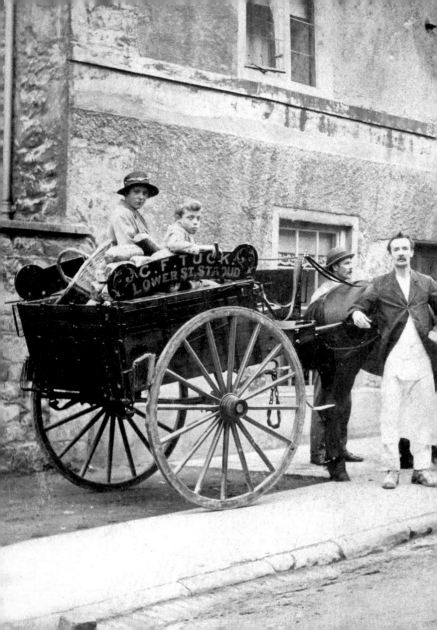

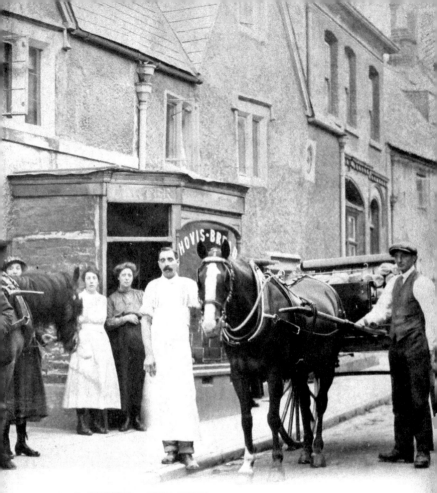

46. LOWER STREET

This bakery in Lower Street was run for many years by various members of the Tuck family. The photo seen here is one of several that depict the firm's staff and delivery vehicles.

ACKNOWLEDGEMENTS

The author is grateful to Peter Griffin, Marion Hearfield, Ian Macintosh and Lionel Walrond for their help in the preparation of this book and to the following for permission to use images: A. Blick, M. Gilles, B. Moss, M. Tyler, Stroud Parish Church, and the Wilf Merrett Collection courtesy of the Museum in the Park.

Grateful thanks also to Sylvia Beard for her patience and skilled assistance.